Bob Ross®

BY THE NUMBERS

by Robb Pearlman

T0364010

RP Minis™
Hachette Book Group
1290 Avenue of the Americas, New York, NY 10104
www.runningpress.com
@Running_Press

First Edition: October 2018

Published by RP Minis, an imprint of Perseus Books, LLC, a subsidiary of Hachette Book Group, Inc. The Running Press name and logo is a trademark of the Hachette Book Group.

The publisher is not responsible for websites (or their content) that are not owned by the publisher.

ISBN: 978-0-7624-9168-1

Contents

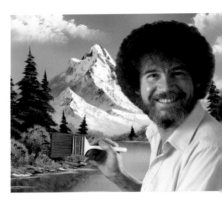

BOB ROSS:
A BRIEF HISTORY

"And that may be the true joy of painting, when you share it with other people. I really believe that's the true joy."

Best known for his calm voice and soothing demeanor, Bob Ross was the host of the world's most famous, beloved, and recognized painting show in the history of television. He

began painting at age eighteen, and after a tour of duty in the US Air Force and various jobs, was inspired by another television painting instructor, Bill Alexander, to develop his own wet-on-wet painting technique (a method that had also been used by such illustrious artists as Caravaggio, Cezanne, and Monet). Over the course of his lifetime, Bob painted nearly 30,000 works, the most popular being the 403 that he painted during his

1982–94 run of his public television show, *The Joy of Painting*. In more than 400 television episodes lasting just twenty-six minutes each, Bob took a blank canvas and, using his signature brushes, paints, and gentle encouragement, guided viewers to follow his in-studio examples to create masterpieces in their own living rooms.

Bob's signature afro may not have been real (it was a perm!), but his love of painting, and his passion for

teaching others how to paint, could not have been more authentic. Bob Ross has, since his death in 1995, gone on to become a cultural and inspirational icon like no other. His popularity as a peaceful, gracious, and sincere teacher, as well as a skilled painter, has crossed not only generations but the world as well. There are currently more than 3,000 certified Bob Ross instructors globally—each of whom carry on Bob's legacy to painters of all ages and skill levels.

With such a legacy, it's no wonder that people have been inspired to paint like Bob. And now it's your turn with the *Bob Ross by the Numbers* kit! Inside are three paintings, each transformed into a miniature work for you to complete. Are you looking to be inspired by Bob every day? Then his portrait (page 12) is perfect to keep beside your bedside table. Need a dose of nature? Paint a landscape with your own happy little trees and clouds

(page 14). Feeling crowded and in need of your own quiet hideaway? Try painting one of Bob's signature country buildings, a charming covered bridge (page 17).

"Let me extend a personal invitation for you to drag out your brushes and a few paints and paint along with us . . ."

MINIATURE
ART HISTORY

**"You have unlimited
power here, you can do that.
You can do anything on
this canvas, anything."**

Before you start painting your own
happy little trees, let's take a look
at each of the paintings featured in
your box. These works represent
the themes frequently found in Bob's

paintings—and will look perfect on your desk when you're finished completing them!

Bob Ross Portrait

Though Bob's essence can be seen and felt in any of the thousands of paintings he created over his lifetime, few elicit the same feeling as an image of the artist himself. From his signature hairdo to his famed smile, you can't help but feel relaxed by just looking at Bob.

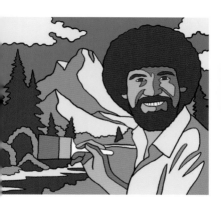

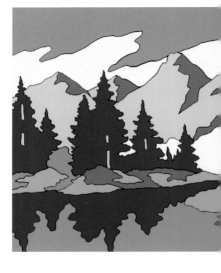

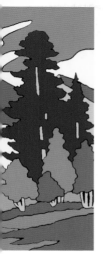

Scenic Landscape

Bob was an avowed lover of nature. He'd often go for long walks to listen to the sounds of the wind and water in and around his property. But even when he was in a television studio, far from the land,

he was inspired to bring nature into his work. Known for his ability to create mountains, trees, rivers, and, of course, happy little clouds with just a few strokes of his paintbrushes and knives, Bob's tranquil, timeless landscapes continue to provide a respite from the hustle and bustle of today's non-stop world. Bob's insistence that there are no mistakes, just happy accidents, provided enough literal and figurative cover for his, well, joy of painting over and around splatters or

marks that may have occurred on the canvas, turning them into snow-capped mountains, babbling brooks, or rocks that looked just perfect right where they landed.

Covered Bridge

Over the course of an episode, Bob was a master of not only painting, but of making each viewer feel like he was talking just to them. Each show is so much more than a tutorial—it is a meditative way for people to relax

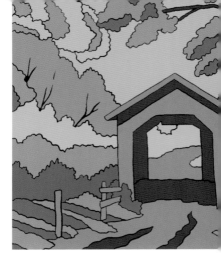

and take a quiet and contemplative moment to center themselves. Bob's frequent use of solitary country structures or buildings surrounded by woods is perhaps a perfect, if not literal, interpretation of his belief that if one stops to look around, the world is a beautiful place.

"We just show you how,
but you make the decisions.
When you have this much
power, you have to make
big decisions."

PAINTING YOUR OWN MASTERPIECE

"Just let your imagination go. You can create all kinds of beautiful effects, just that easy . . ."

Now it's time for you to create your own Bob Ross painting. Inside this kit is everything you need:

- Three pre-printed canvases with numbered sections

- Seven paint pots (red, green, yellow, blue, black, white, brown)
- Mini paint brush
- Mini easel for displaying your finished works of art
- Full-color, fold-out sheet with detailed painting instructions for each work

Let's get started!

How to Paint (by Number) like Bob

1. Choose your canvas: Bob Ross's portrait, the Scenic Landscape, or the Covered Bridge.

2. Plan your palette. Try to adhere as closely as you can to the paint colors that Bob preferred by mixing your paints to match. To do so, pick as many colors as there are numbers on the canvas and assign a color to each number. For example: 1=Yellow, 2=Blue,

3=Purple (mixed from red and blue). For tips on mixing your own colors, see the chart on page 28.

3. Pick one color from your palette and paint every section marked with that number. For example, if color "1" in your palette is yellow, paint all "1" areas yellow. Try to stay inside the lines!

4. Like Bob, be sure to wash your brush off in some water (and dry it by beating it against a sturdy surface far from your canvas)

before moving onto the next number/color. Keep rinsing and repeating (and beating the devil out of your brush) until your entire canvas is filled in.

5. Master the art of patience next. Don't feel pressured to finish your painting as quickly as Bob completed his. Take your time and enjoy the process. And don't forget to sign your painting just like Bob did (but with your own name, of course). Give your

finished piece some time to dry, and then show it off to your family and friends!

6. Look at it. Just look at it. Beautiful! As Bob would say, "I knew you could do it." Display your miniature masterpiece on the easel provided or anywhere you please.

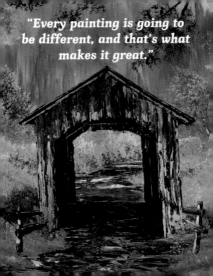

"Every painting is going to be different, and that's what makes it great."

Mixing Colors

Here's a chart for creating new colors from those included in your kit. Additional mixing to create, for instance, a perfect tree green, will be required.

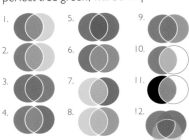

TO GET:	MIX:
1. Green	Yellow + Blue
2. Orange	Red + Yellow
3. Violet (Purple)	Blue + Red
4. Violet-Red (Fuchsia)	Red + Purple
5. Blue-Violet (Indigo)	Blue + Purple
6. Green-Blue (Teal)	Blue + Green
7. Yellow-Green (Lime Green)	Yellow + Green
8. Orange-Yellow (Marigold)	Yellow + Orange
9. Red-Orange (Burnt Orange)	Red + Orange
10. Pink	Red + White
11. Gray	White + Black
12. Brown	Purple + Orange, Purple + Green, Green + Orange, or Red + Blue + Yellow

- Mixing different proportions of the colors from the right column will yield different shades of the left column—have fun with it and find your perfect shade!
- To lighten any color, mix in white until you reach your desired shade.

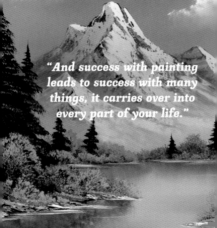

"And success with painting leads to success with many things, it carries over into every part of your life."

This book has been bound using handcraft methods and Smyth-sewn to ensure durability.

Designed by Ashley Todd.

Illustrated by Mario Zucca.

Written by Robb Pearlman.